The Dante Paintings

MAIA NEWLEY

The Dante Paintings
© Maia Newley Art 2013

*"Abandon all hope, ye who enter in..."**

- *Dante Aligheri*

INDEX

ACKNOWLEDGEMENTS …………………………… 4

FOREWORD …………………………… 5

PREFACE …………………………… 8

THE DANTE PAINTINGS …………………………… 14

MARBLE SEAS PAINTINGS …………………………… 23

STRUM AND DRANG PAINTINGS …………………………… 29

DIPTYCHES, TRIPTYCHS & TETRAPTYCHS …. 36

ACKNOWLEDGEMENTS

The Dante Series of paintings were something of a mammoth undertaking and pretty much everyone who has been involved in my life over the past couple of years is owed huge thanks from me and I offer my thanks gratefully in this book.

In particular, enormous thanks must go to John Markton for his careful and patient proofing of the various versions of the book and for being the best unpaid counsellor anyone could ask for! To all my friends, whom I won't name individually for fear of leaving someone important out, please accept my sincere thanks for being there for me over the years.

To my other half, I apologize for months of near-madness as I created this series of artworks and I thank him for continuing to love me, for remaining sane, and for keeping me up-to-date with the Chicago Blackhawks results for the duration of the project!

To Charlie, thank you for being you and for believing in me.

And to everyone else who has had ANY part at all in the creation of The Dante Paintings, thank you, from the bottom of my heart.

<div style="text-align:right">MN</div>

FOREWORD

About Maia Newley

Maia Newley is an abstract expressionist artist who lives between the USA and the UK. Her work focusses predominantly on colors, textures and emotions and the interplay between all three. Her previous series have included "Dante – Inferno – Hell" and "Faustus – Denouement – The Conclusion" which both explore the relationship between mankind, evil, eternity and man's belief in the supernatural.

She has exhibited in the USA, UK and Europe and is committed to producing 'accessible art' which is shown in appropriately accessible environments. She has regularly shunned opportunities of exhibiting in conventional galleries in favor of open-air, freely-accessible exhibitions and open-space galleries which offer full access to visitors with no entrance fee. She strongly believes that art belongs to everyone and should not be viewed any differently to music (which she also composes) – everyone should have free access to art if they wish to view it. She views her work as coming from an anarchistic start point and, for this reason, she endeavors to ensure her work is available and viewable to anyone who wishes to see it, regardless of income, status or education. As Maia herself says :

"... There are some galleries I have exhibited in in the past, where even I, as the artist, feel uncomfortable going in the door – as though I am entering some hallowed hall where I can only walk in if I am wearing the right outfit and only speak in whispers using words of more than three syllables. Goodness alone knows how the casual passer-by might feel on seeing the work through the window and wishing to pop in to view it in more detail. I do not want my art work displayed in such a place. Life is art and art is life, and therefore is it imperative that we do not separate the two or put one on a pedestal above the other."

Although Maia works predominantly as an expressionist, she also has occasional forays into the areas of symbolism and fauvism. Over the years she has worked with a plethora of different media including sculpture, stone casting, metalwork, pyrography, stained glass window design and more conventional painting. She is also a photographer.

When asked about her work, Maia says :

"I don't have a whole lot to say really as I prefer the art to speak for itself. In my opinion art needs to be accessible to all those who wish to see it. What any given piece means to me is mostly irrelevant as the viewer should decide what it means to THEM. In this way, I hope that each piece can develop its own meaning for each person who views it.

I prefer not to give long explanations with the artwork as, for me, art is about feeling and emotion and not about words.

My main interest is in producing pieces which focus on areas of the world about us which we mostly don't bother to look at! Individual rain drops, small parts of brickwork, clumps of earth - in other words, I focus on the minute details which do not generally draw our attention when we look at the overall subject matter.

My work is mostly abstract expressionist in nature, but I seem to have a natural affinity with symbolism which is hard to shake-off and so much of my work is underpinned with a symbolistic conception which then mutates and grows into its expressionistic form. I find the fusion of the two styles is probably the best way of understanding who I am as a person - that paradox, between the more stylized and regulated symbolism and the randomness of the expressionistic conclusion accurately reflects the seemingly interminable conflict which exists within my mind between order and chaos. After years of trying to resolve the conflict, I have now finally concluded that I am who I am BECAUSE of that conflict and not in spite of it!

If you're looking for representational art, you won't find it here! For me, if you want to look at fine art paintings of landscapes, buy a camera and take photos! If you want to look at how a landscape makes someone FEEL, look at art".

MN

PREFACE

INTRODUCTION TO DANTE & THE DIVINE COMEDY

Dante's Divine Comedy was written between 1308 and 1321. Interestingly, Dante originally named the work "La Comedia", the word 'divina' (or 'divine') was added in by Bocaccio and not by Dante himself.

The Divine Comedy is a poem – more than a poem really – it's a life's work. As any student of Dante will be able to tell you, he was a complex individual with a strangely meandering history for the time in which he existed. In his early life, he wandered around Italy and parts of Europe mixing in a variety of social circles but had definite political ambitions which were, sadly in Dante's own view, never able to come to fruition. He also had great interest in philosophy and certainly The Divine Comedy adroitly illustrates a great deal about Dante's own philosophy of life.

Dante's mother died when he was still a small child and this undoubtedly had an effect on the person that he became in later life. Despite marrying Gemma Donati according to his father's wishes, his professed an unrequited love for a young girl named Beatrice Portinari who died in 1290 leaving Dante apparently feeling permanently bereft of a love and soul mate. It is often argued that Beatrice formed the central focus behind The Divine Comedy and, whether this is true or not, she certainly had an enormous impact on the rest of his life. In 1295 he published Vita Nuova (New Life) which he claimed was a love poem for Beatrice and described in terms of a 'tragedy'. Dante usually wrote in Latin and it is perhaps cursorily interesting to note that Vita Nuova was written in Italian.

Following Beatrice's passing, Dante became interested in philosophy and politics, focussing predominantly on the Florentine political arena. He met with some success in Florence and held various reasonably important roles but, by 1302, the powers-that-be in Florence had tired of him and insisted that he be exiled from the city. The exact reasons claimed for his exile are complex and difficult to elucidate firmly and they need not particularly concern us for this venture, but suffice to say, there was huge conflict at the time between the powers representing the Empire and the powers representing the Papacy in Italy and this led to tumultuous chaos and enduring conflict ensuing much of the time. It may well be that Dante's experiences in Florence informed his overall perception of 'The Church' and 'The State' when he came to write The Divine Comedy.

Subsequent to his exile, Dante began travelling and seems, in 1304 to have arrived in Bologna. During this period of his life he began writing The Divine Comedy and withdrew from any political activities whatsoever. While in Bologna he wrote De Vulgari Eloquentia (The Eloquent Vernacular) in which he expounded the virtues of Italian in an attempt to have it viewed as a serious literary language (which he felt it was not at the time). He believed that an attempt to

unify both written and verbal language may help to bridge some of the huge social, political and class divides which existed in Italy at the time.

In 1306, all those who had been previously expelled from Florence were expelled from Bologna and so, from here, Dante made his way to Padua and after this period, his movements become very much more difficult to trace. There are some reports which claim he spent a couple of years in Paris during the early 1300's but it is extremely hard to verify this.

In 1308 the political scene changed and Henry of Luxembourg was elected as Emperor which seems to have filled Dante with hope for the future and it was at this time that he wrote De Monrchia (The Monarchy), a series of three books, in which his main claim is that the authority of the Emperor is not dependent on the Pope but descends directly from God himself. This new political optimism did not last long however and soon Italy was in chaos again with enemies of the Emperor threatening his ascension. Dante regarded the dissenters as consisting mainly of Florentine political powers and wrote a forthright tirade against them voicing his opposition and this, of course, immediately resulted in Dante being permanently banned from Florence!

It is thought that Dante began The Divine Comedy in earnest at around this time. In 1312, there are reports that Dante began meeting up with other exiled citizens and with supporters of the new Emperor at Pisa (as an aside, it is salient to note that Henry's ascension was finally sustained and he was named Holy Roman Emperor in 1312). By 1314 Dante had completed The Inferno section of The Divine Comedy (the section which is set in Hell) and he finally settled in Ravenna where he completed the full work shortly prior to his death in 1321.

There are a plethora of different interpretations of The Divine Comedy, of its meaning, and of its intention and I believe it is up to each reader to decide which interpretation they choose to give most credence to. Indeed, perhaps it is not important how others view the work, perhaps it is only really important how each reader views it themselves.

Dante was indeed a very complex individual who lived life very much as he felt it, refusing to hide his passions and beliefs and regularly suffering for both. I suppose the simplest way of summing up The Divine Comedy without overlaying my own personal interpretations onto the reader and with as little bias as possible is to say that, in general, it can be viewed as an allegorical work which depicts human life as though it were a trip through the afterlife. During this 'journey' the traveller who is the central focus, meets with various historical figures. The Roman poet Virgil acts as his guide as the traveller makes his way through the first two stages (Hell and Purgatory) while Beatrice guides him through Heaven.

Dante explains that the journey takes place in 1300, beginning on the evening before Good Friday and ending on the Wednesday following Easter (which date, it is interesting to note, makes it prior

to his own exile from Florence and, indeed, Florence provides a metaphorical backdrop to much of the work and could be said to underpin the entire journey.

I don't intend to write a literary review of The Divine Comedy here but, if the reader is interested, there are many excellent works available by true scholars of Dante and I would urge the reader to investigate those on offer. For my purposes here however, it is enough to merely set the scene of Dante's life, explain a little about who he was as a person and to (hopefully) give the reader an overall view of the man who came to write The Divine Comedy.

ABOUT THE DANTE PAINTINGS

I suspect that this is the part of the book where I have to own up to a near lifelong obsession with Dante's Divine Comedy! For years, it had been a tome which had sat on my bookshelf staring at me, partially read and regularly flipped through but never to its final denouement. Finally, one day, I got tired of feeling beaten by a book I genuinely did want to read and so I took it down from the shelf yet again and decided to apply myself to actually reading it through!

It didn't take nearly as long as I'd anticipated, possibly because I'd invested in an excellent translation which had very useful notes incorporated. Before long, I realized that it was drawing me into its sublime and abysmal depths and I was then keen to try reading it in the original language. This took a little longer!

I don't give this preamble as some sort of self-congratulatory note, but because I think The Divine Comedy is one of those books which certainly can seem inaccessible to readers both because of its length and because of the apparent complexity of the subjects covered. However, if you have never leafed through it, I would urge you to do so as it really is a quite remarkable piece of writing.

Project Gutenberg offers free and downloadable copies of several translations of The Divine Comedy and therefore, if you do not feel moved to part with any money for it, do take a look at Gutenberg's site.

As an artist, I find inspiration in the most unlikely of places at times but, with my Dante paintings, I think they were really almost halfway to fruition the moment I started properly reading Dante. I really can't imagine NOT having wanted to paint them! As an expressionist artist, I find Dante's works lend themselves beautifully to imagery and pictorial representation and, over the centuries, many other artists have also felt the same, leading to an interesting collection on Dantean artwork being available. Dante writes with a very raw emotional pen and, of course, this translates perfectly into expressionistic art which, for me at any rate, is almost always entirely based in emotions.

Over the years, my artistic style may have changed and hopefully developed, but the central tenet to all my works is that of emotion, feeling, life, texture, color and the relationship between all of the aforementioned. Sometimes I use straight forward canvas and paint but often recently I have chosen to use a variety of different media and, in some cases, opted to mix media; using conventional paint and canvas together with digital filtering or screen printing an original painting onto an unusual surface. The works of Dante Alighieri really do offer the artist an amazing opportunity for absolute freedom and this, for me as an anarchist expressionist, is always my main aim whenever beginning a new series of paintings.

In order to give the reader the best possible view of each piece, I have chosen to use large images, one on each page of the book. There are no titles for any of the works in this series as the aim of my art is always to open up the possibilities for the viewer. To allow the person looking at it to choose what they take away from it. What I mean by it is largely irrelevant, how it makes you as the viewer, feel, when looking at it, is the only thing which really matters...

And so, dear reader, here we go...

THE DANTE PAINTINGS

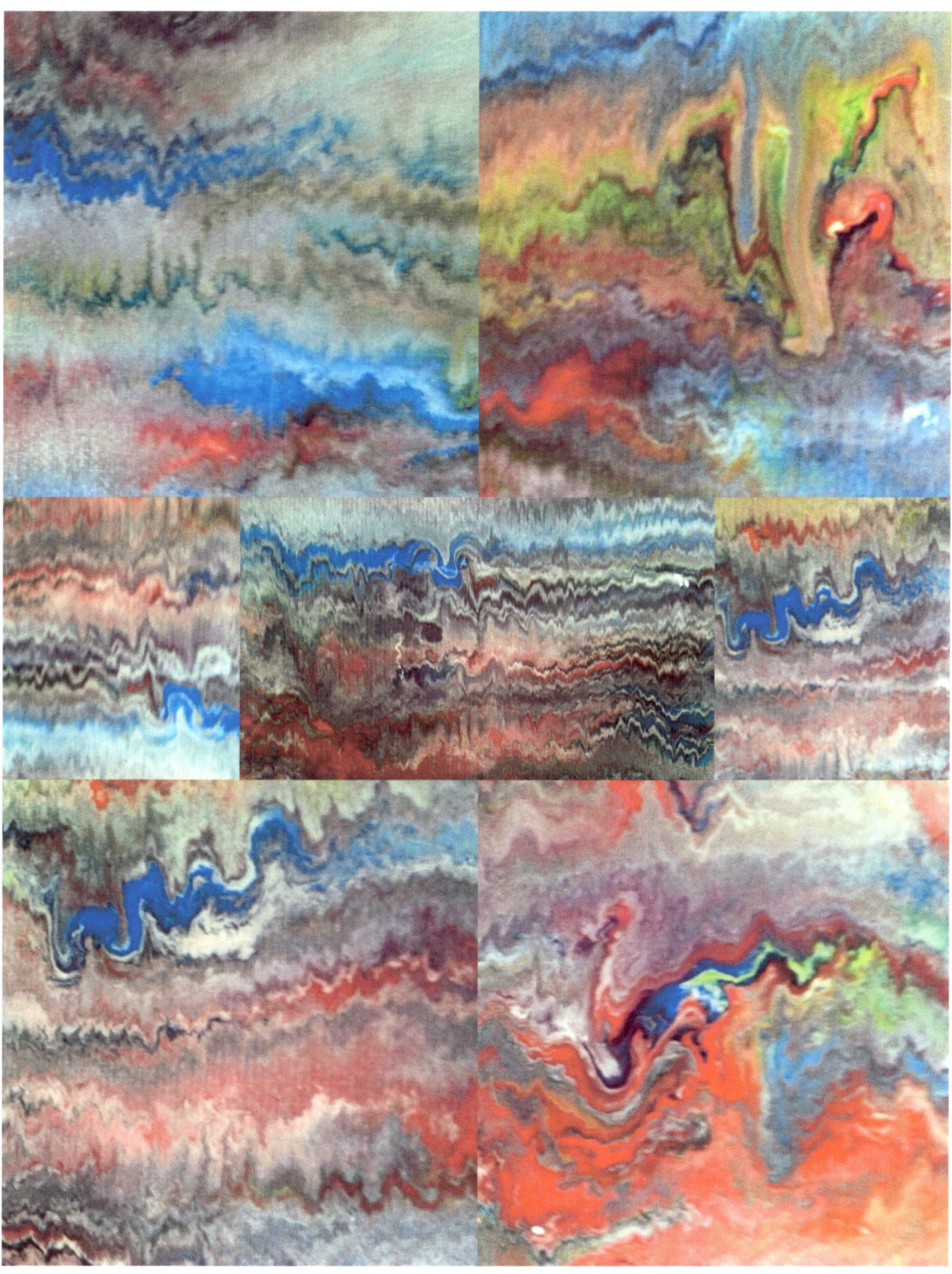

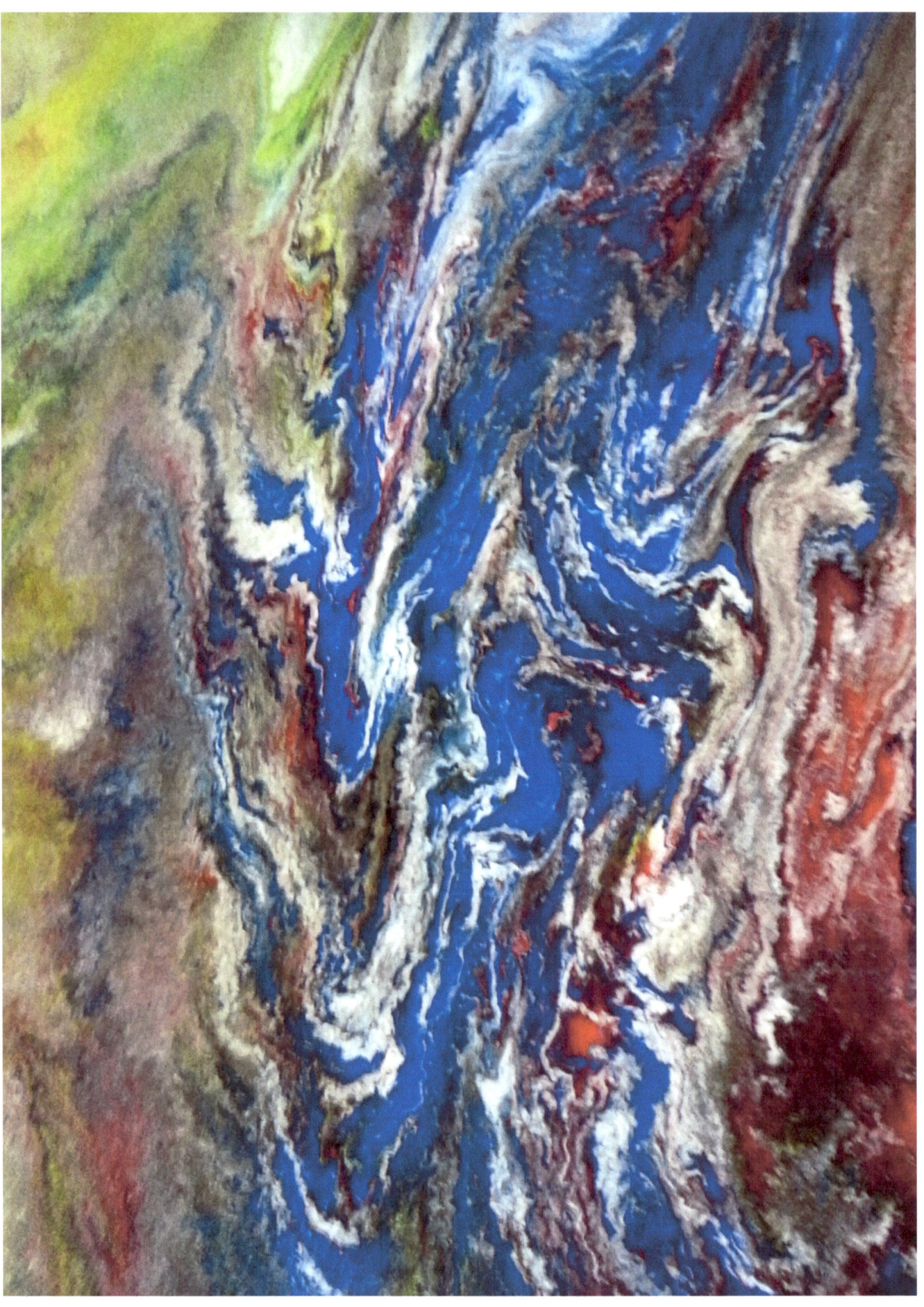

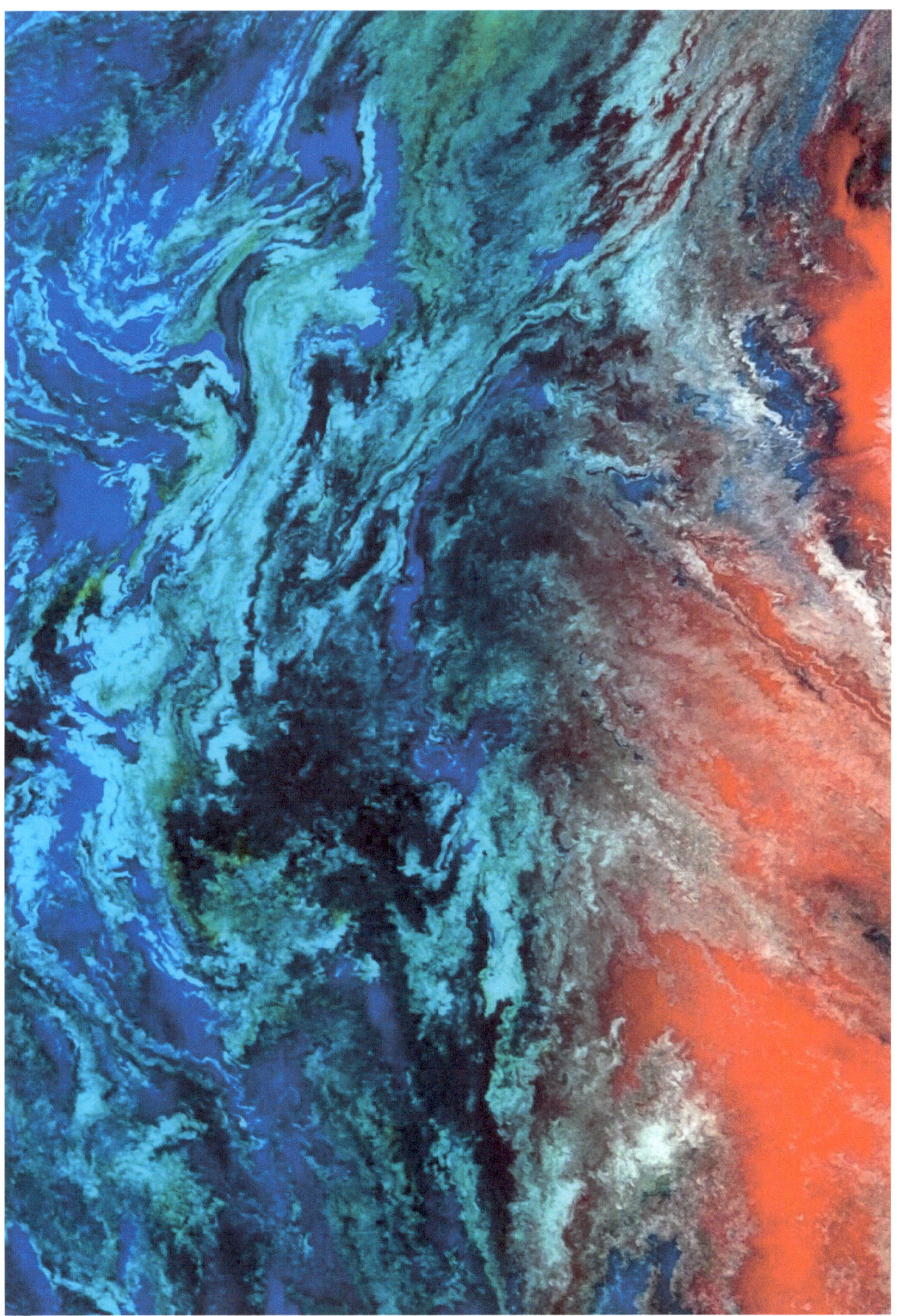

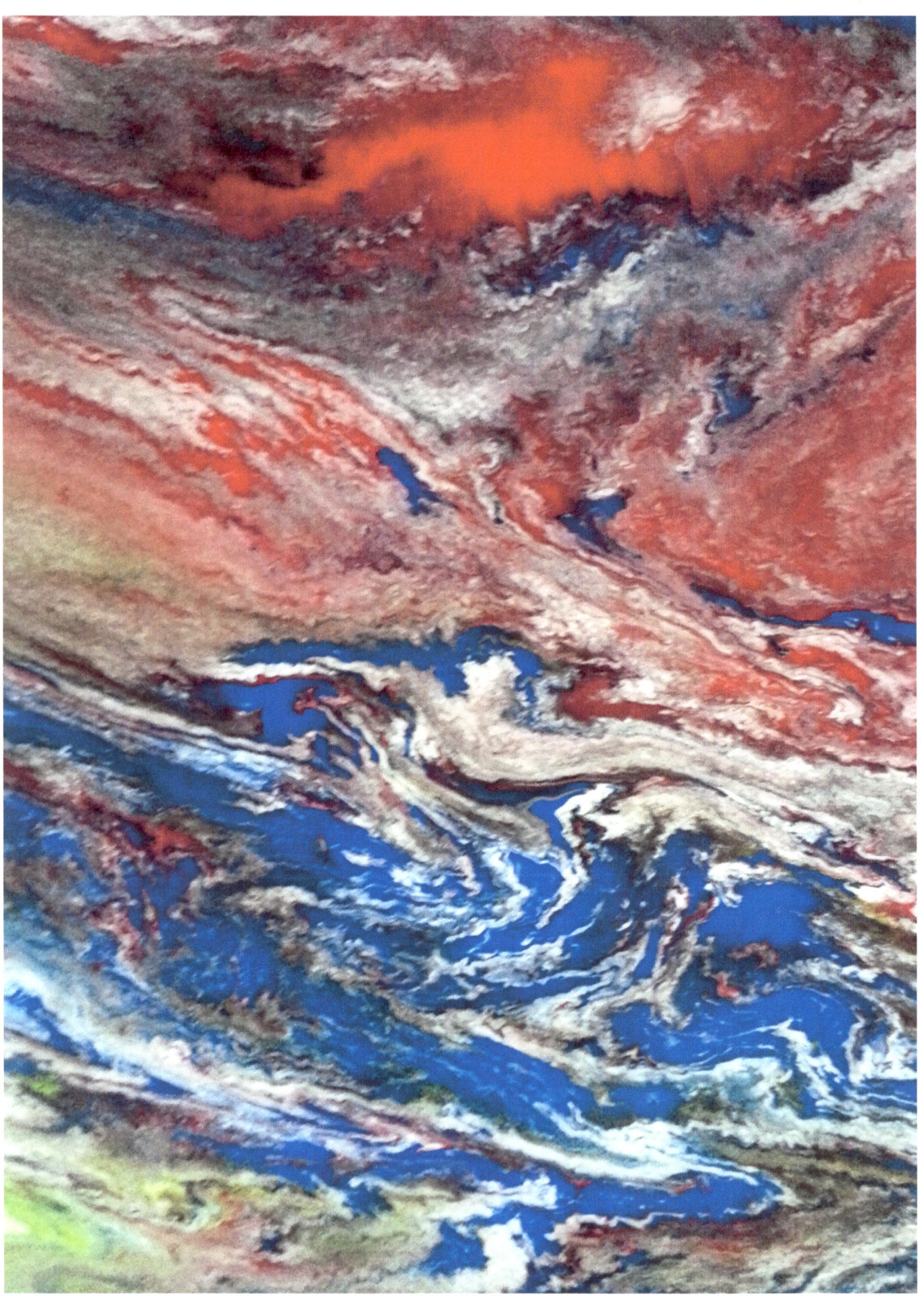

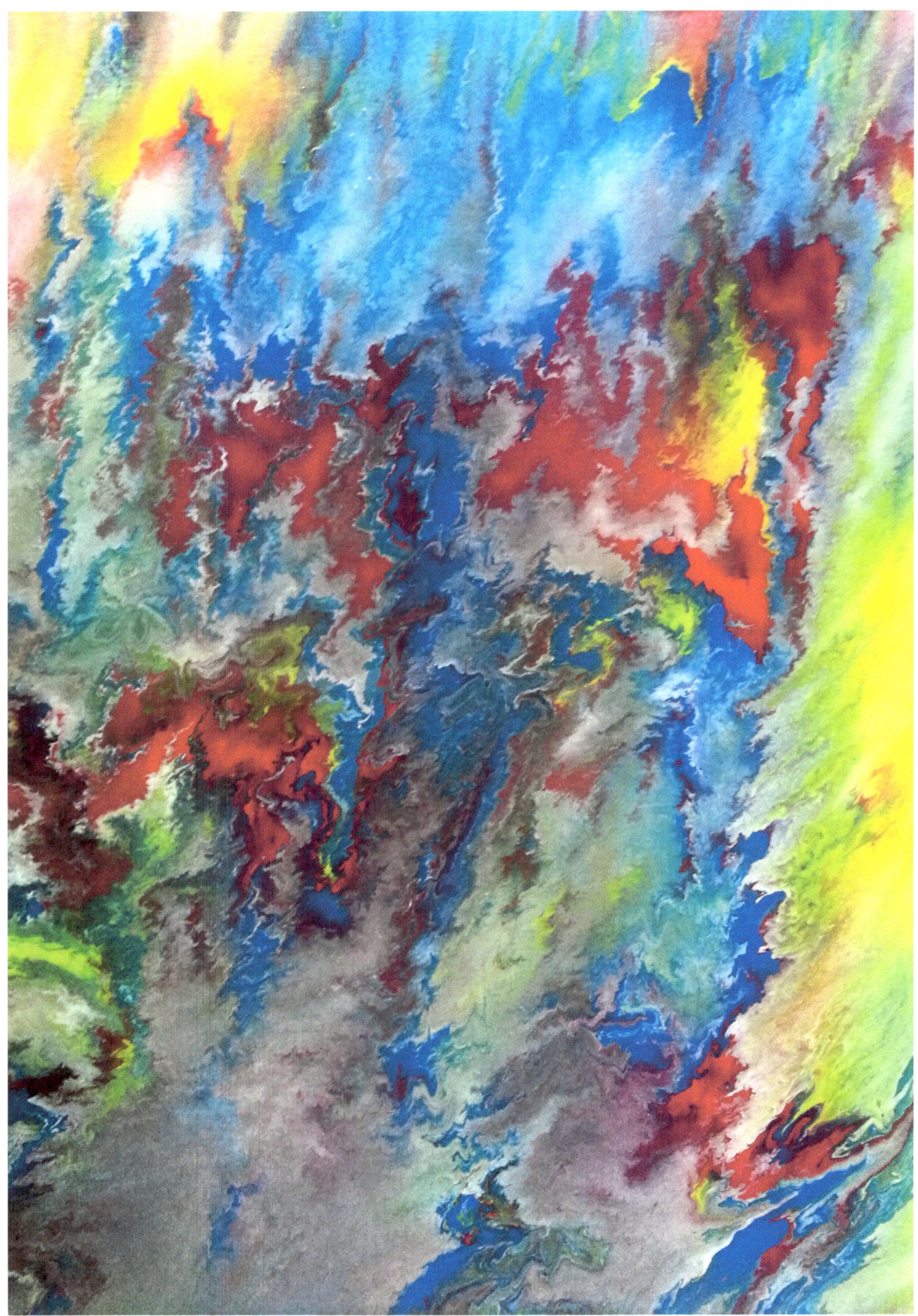

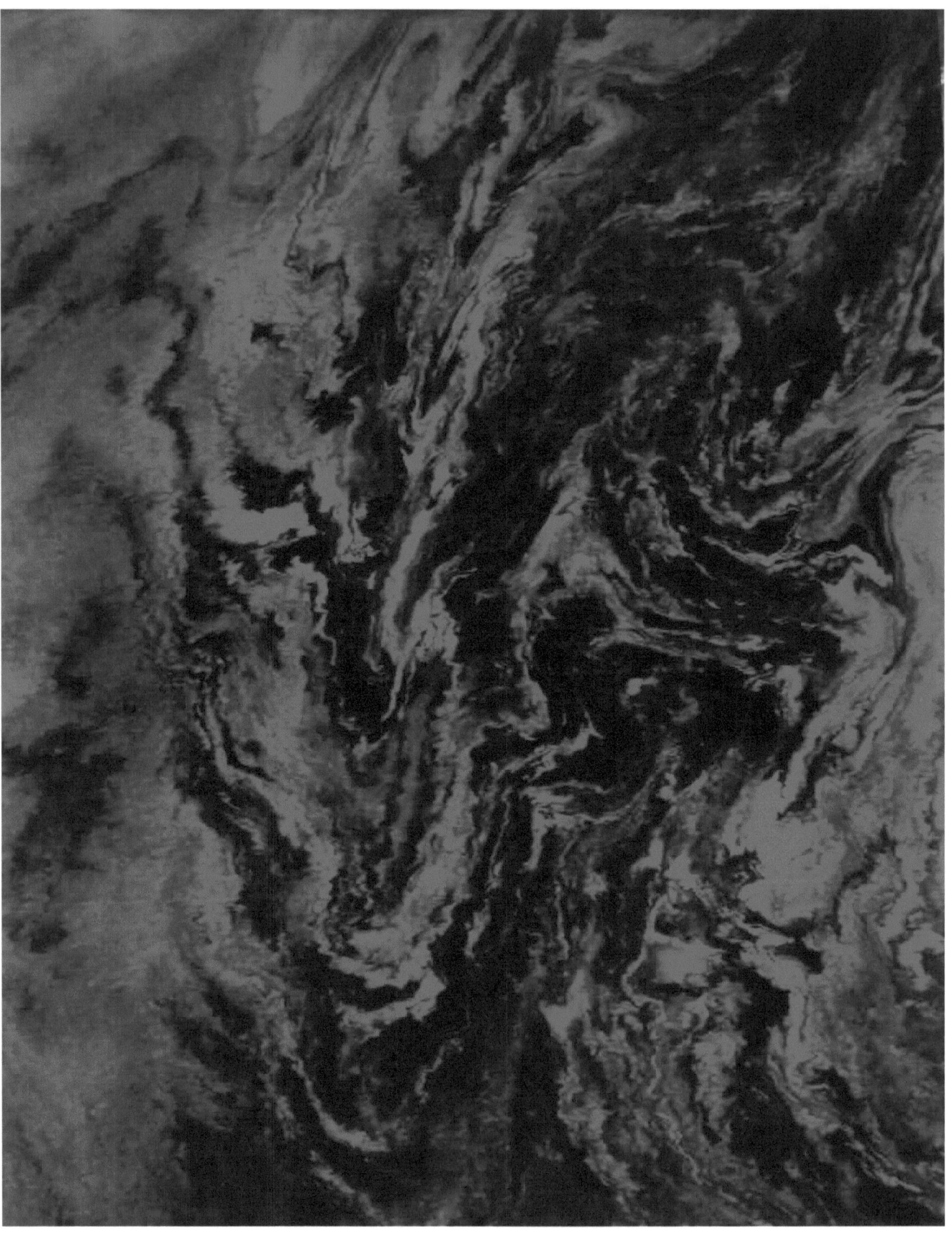

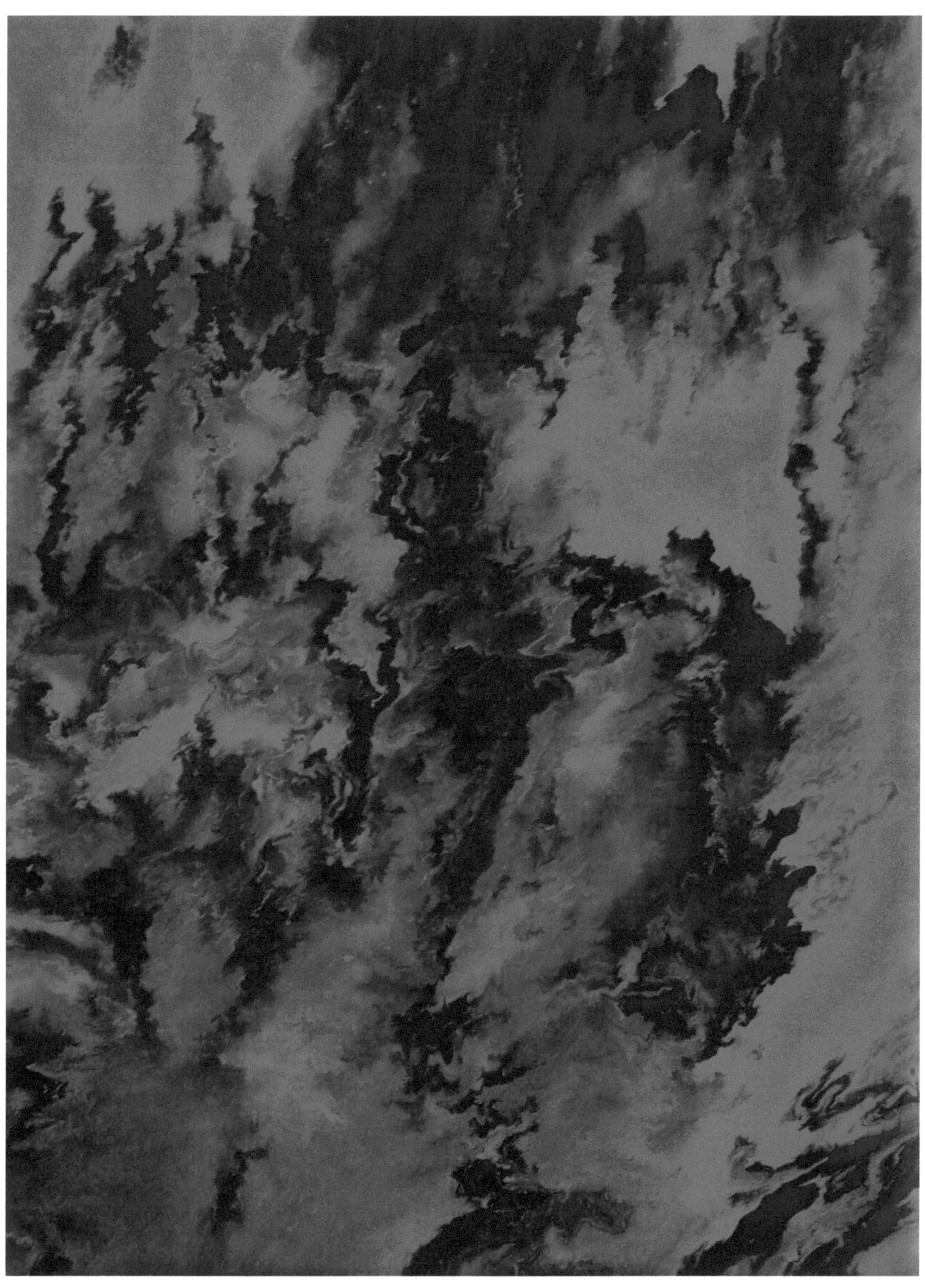

THE MARBLE SEAS PAINTINGS
DANTE EXHIBITION

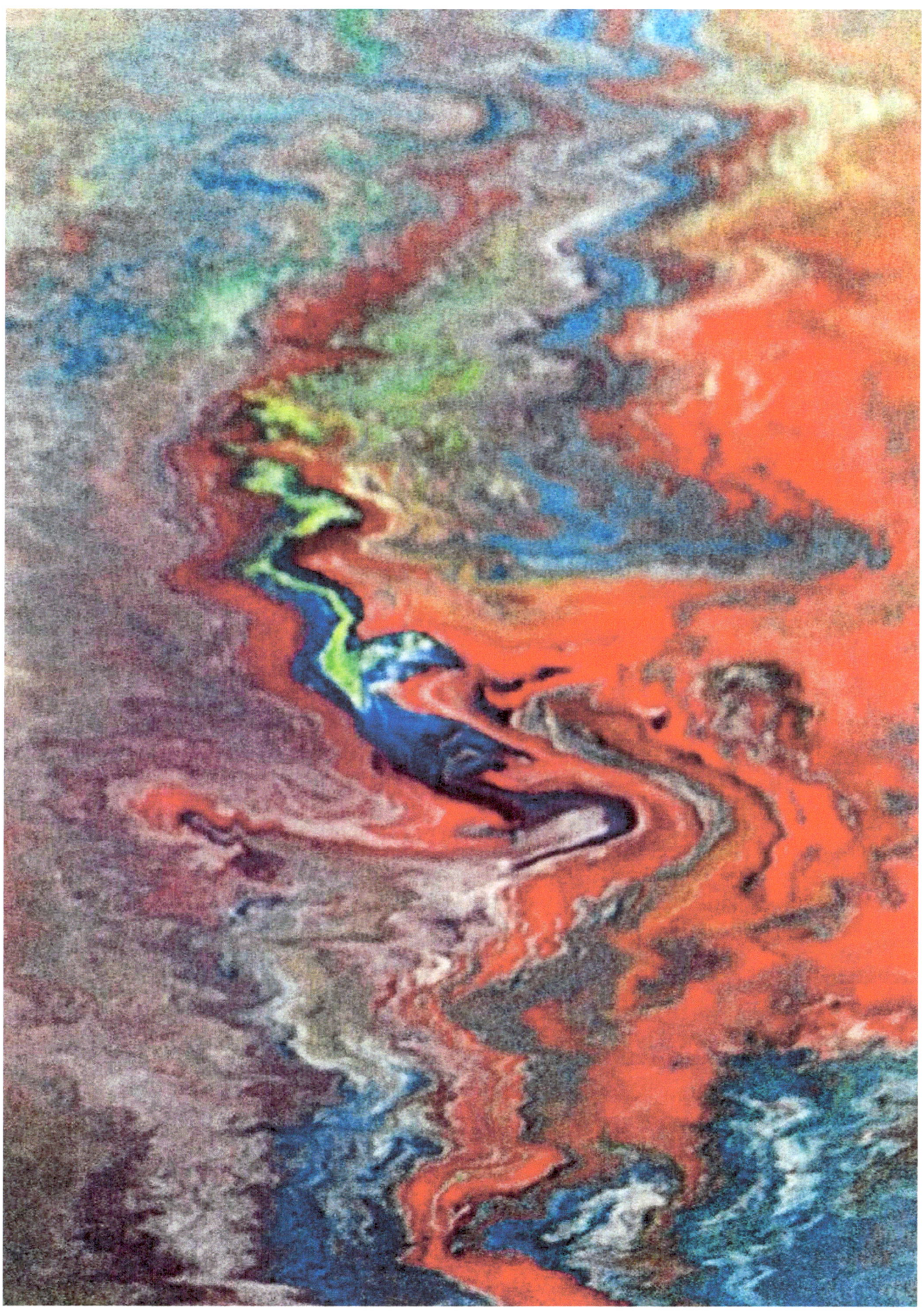

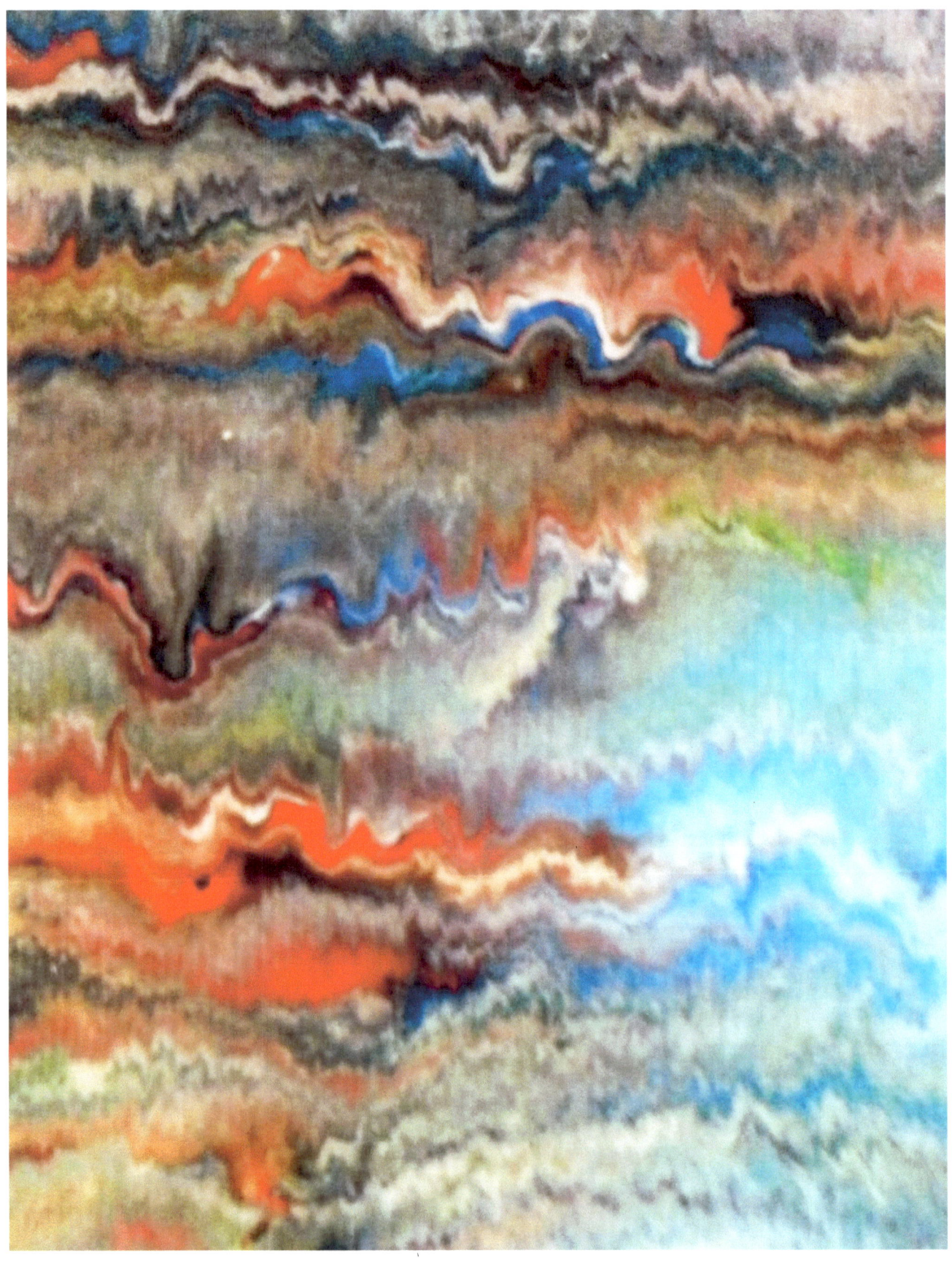

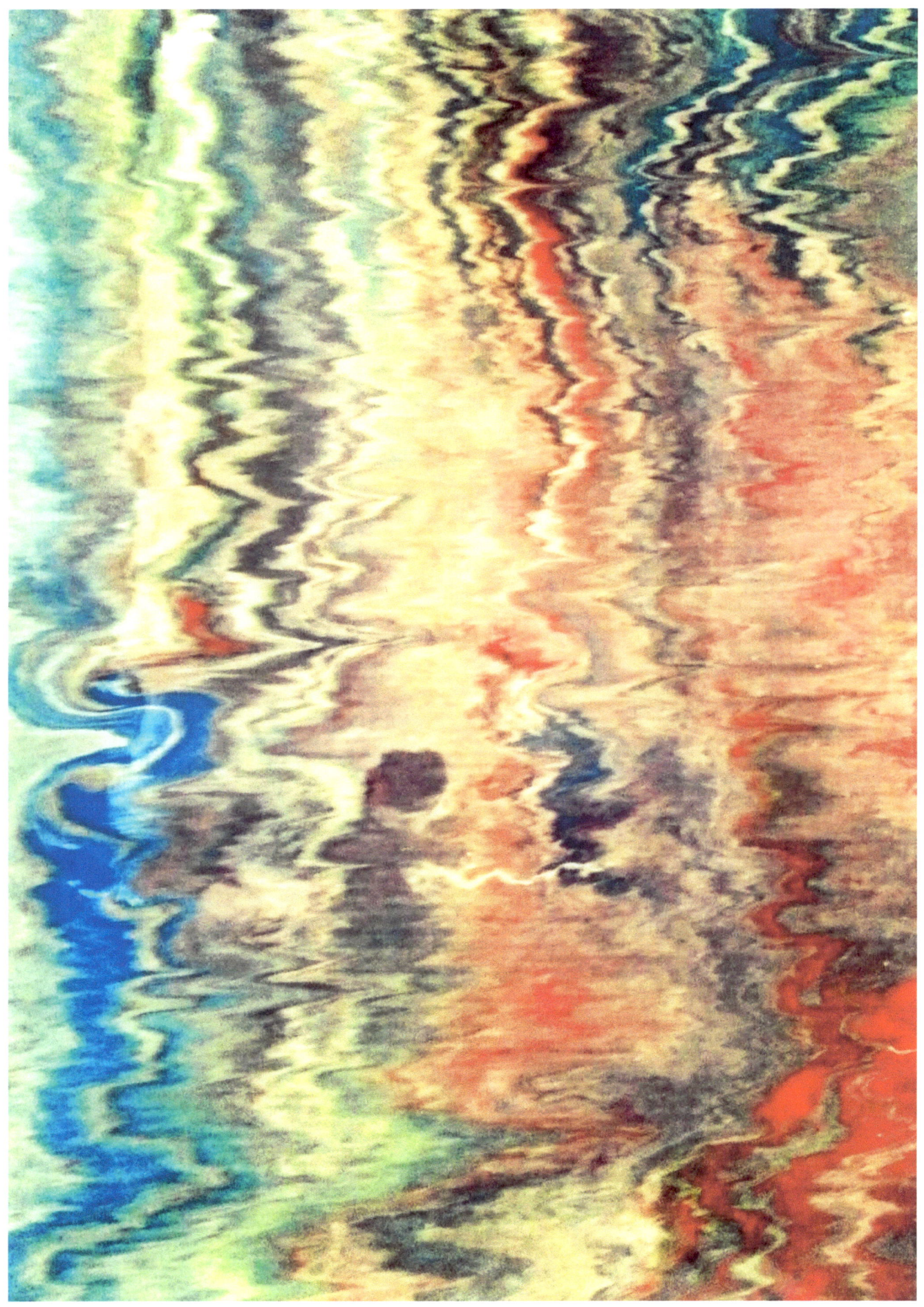

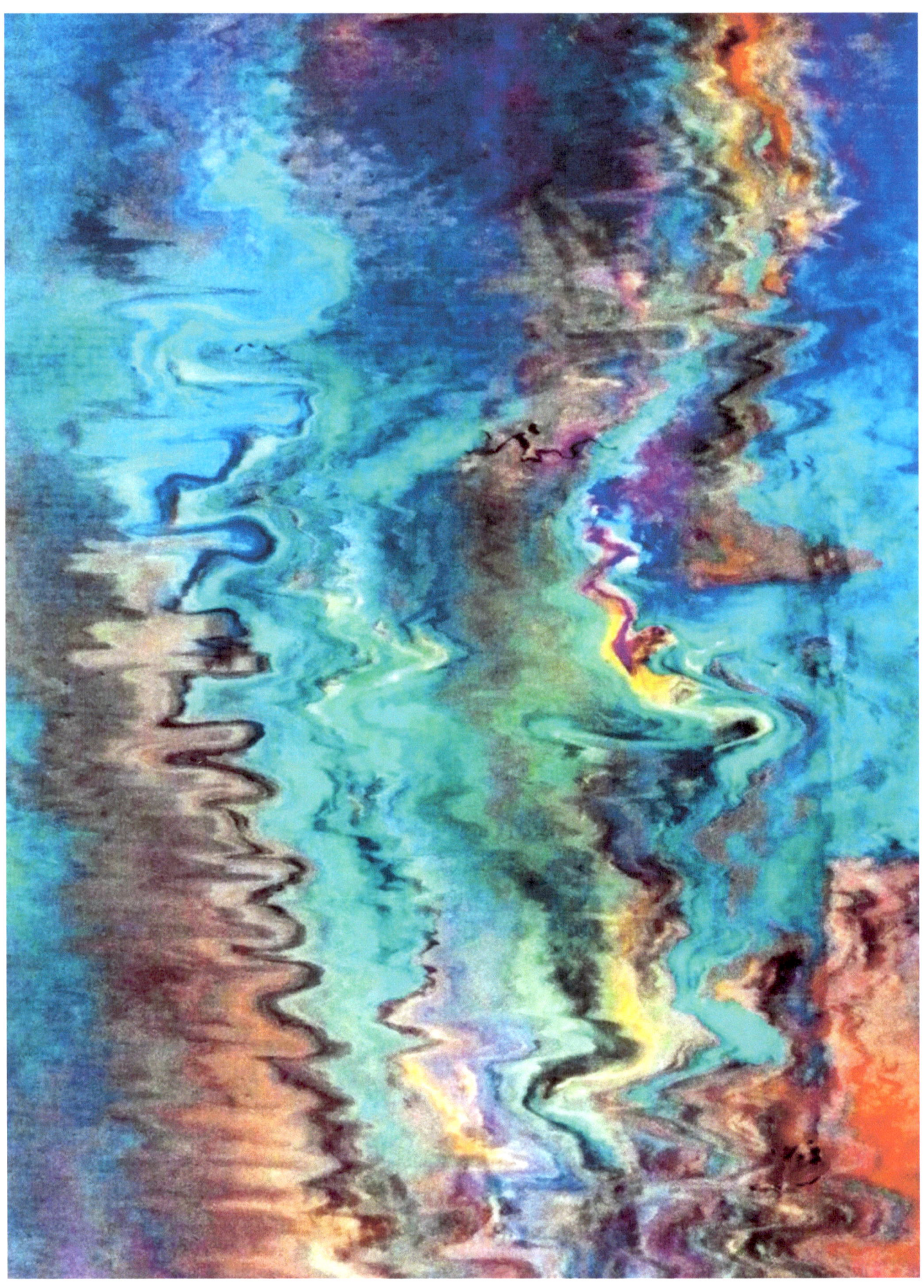

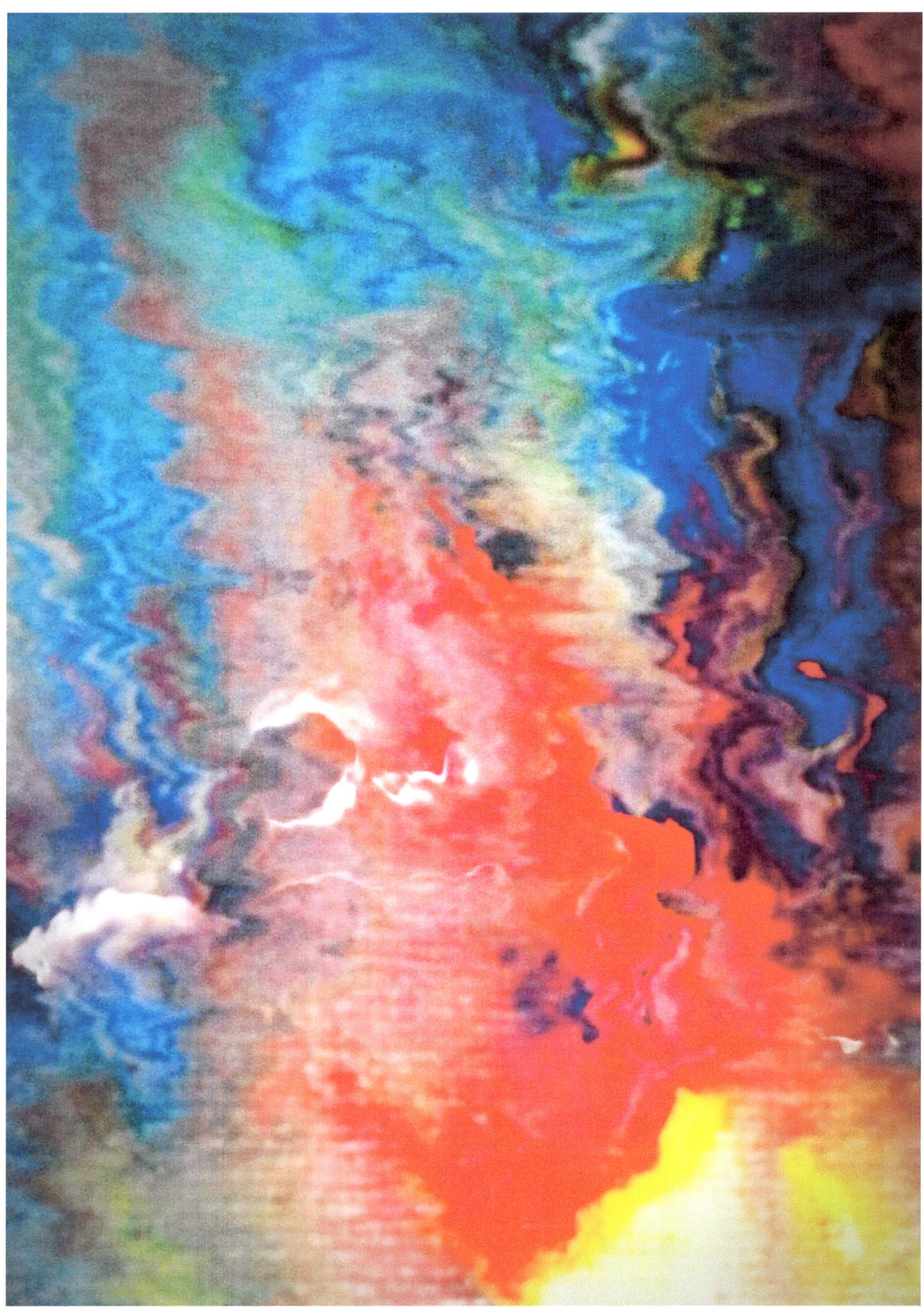

**STURM AND DRANG PAINTINGS
DANTE EXHIBITION**

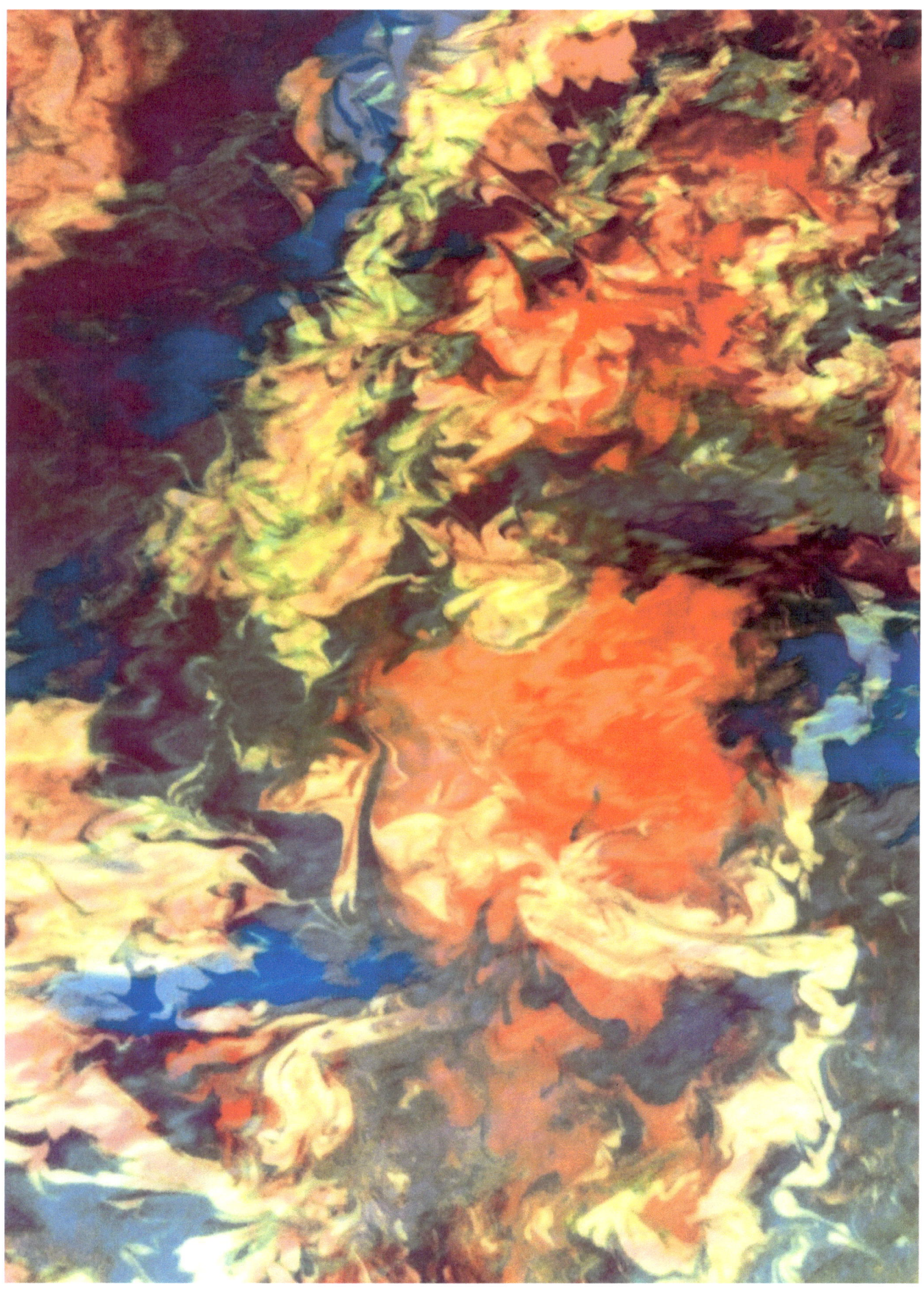

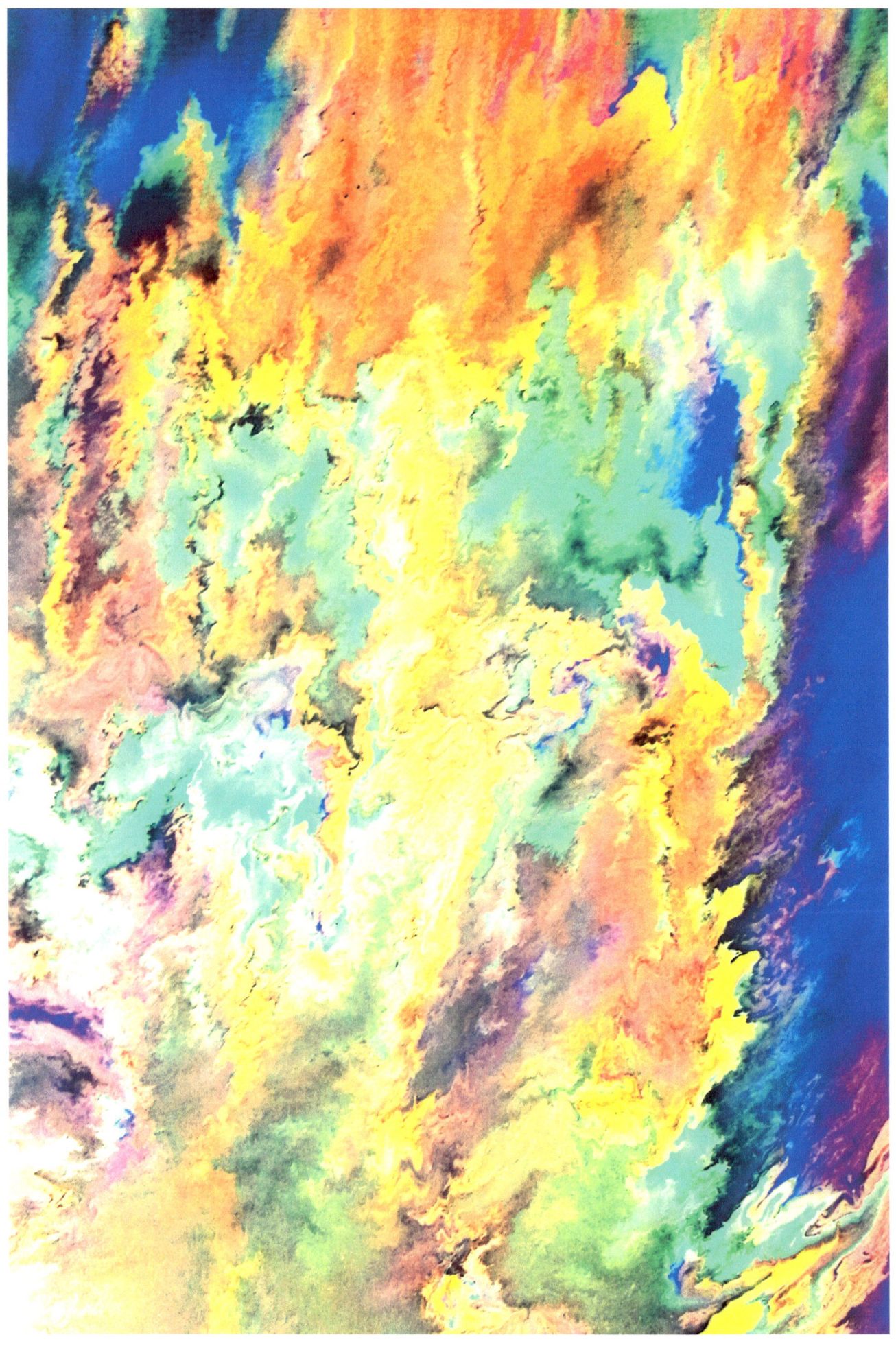

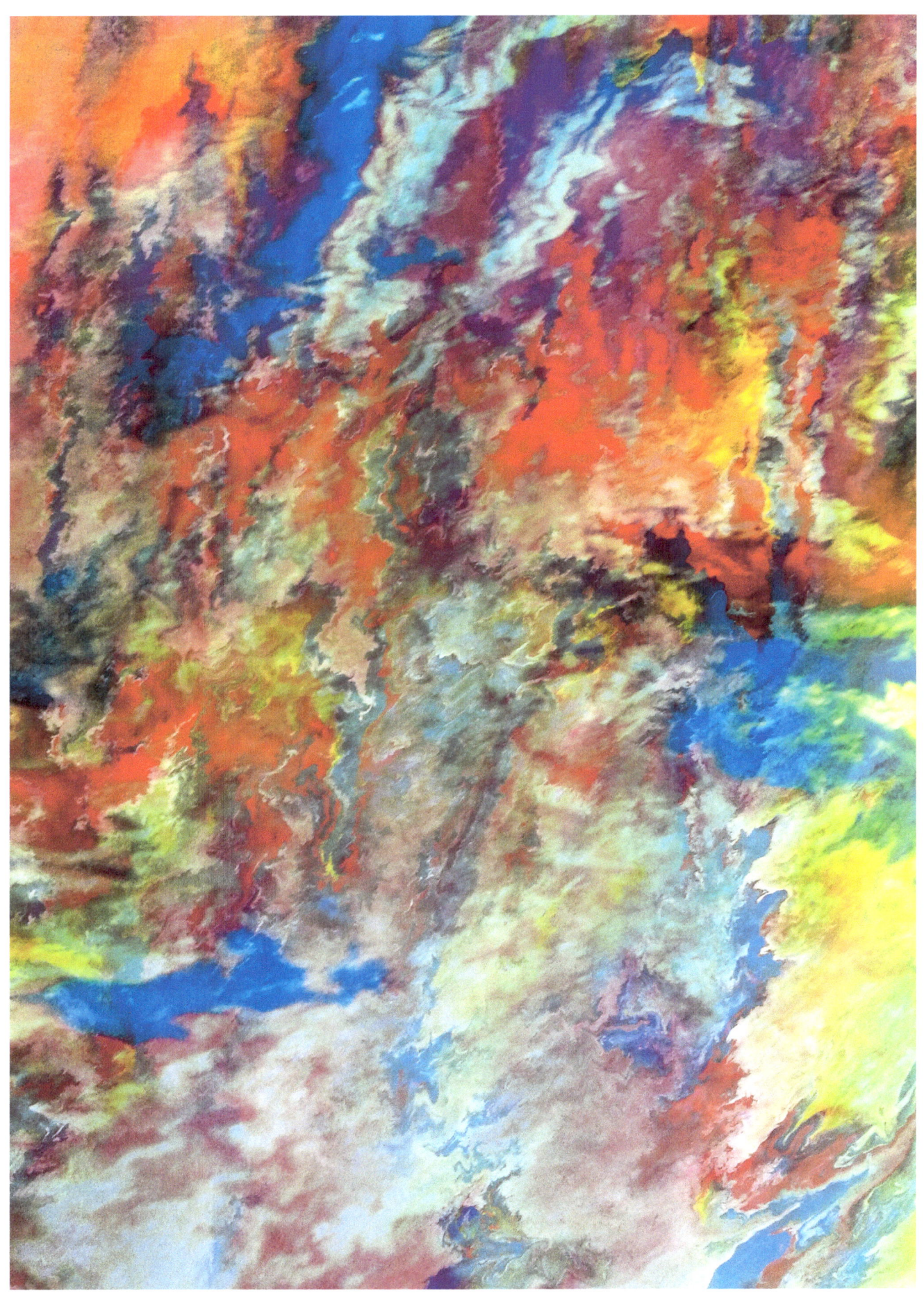

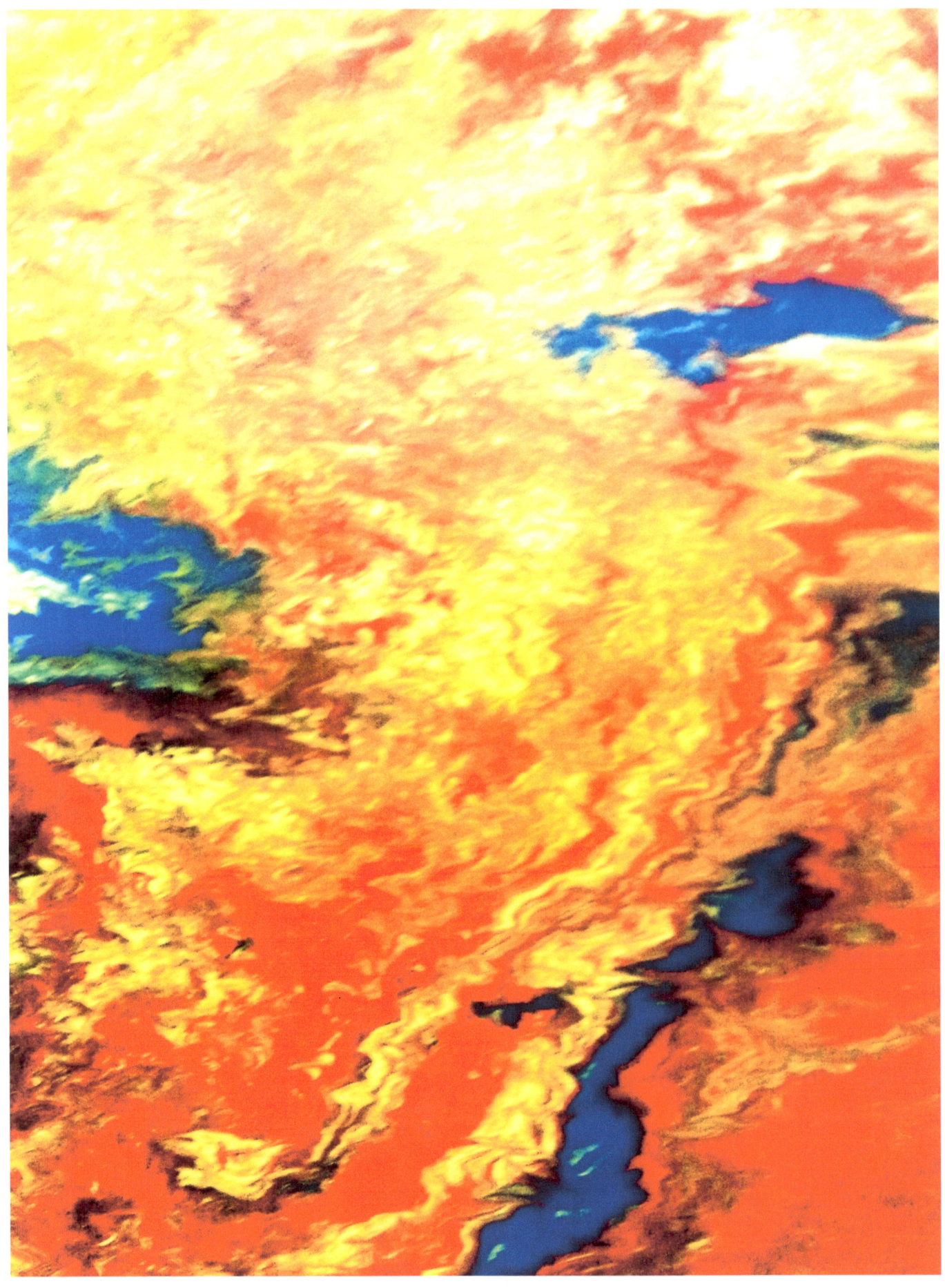

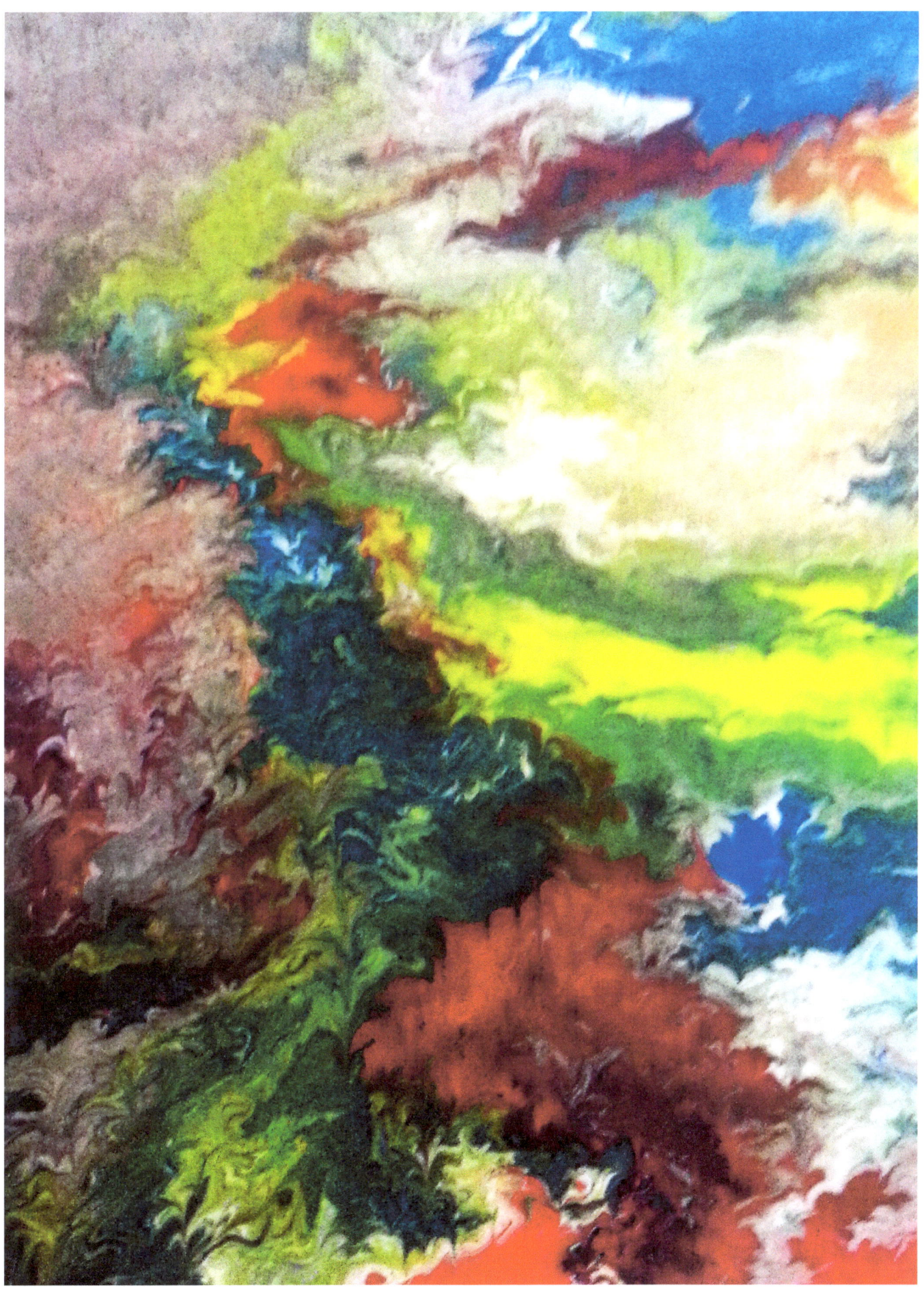

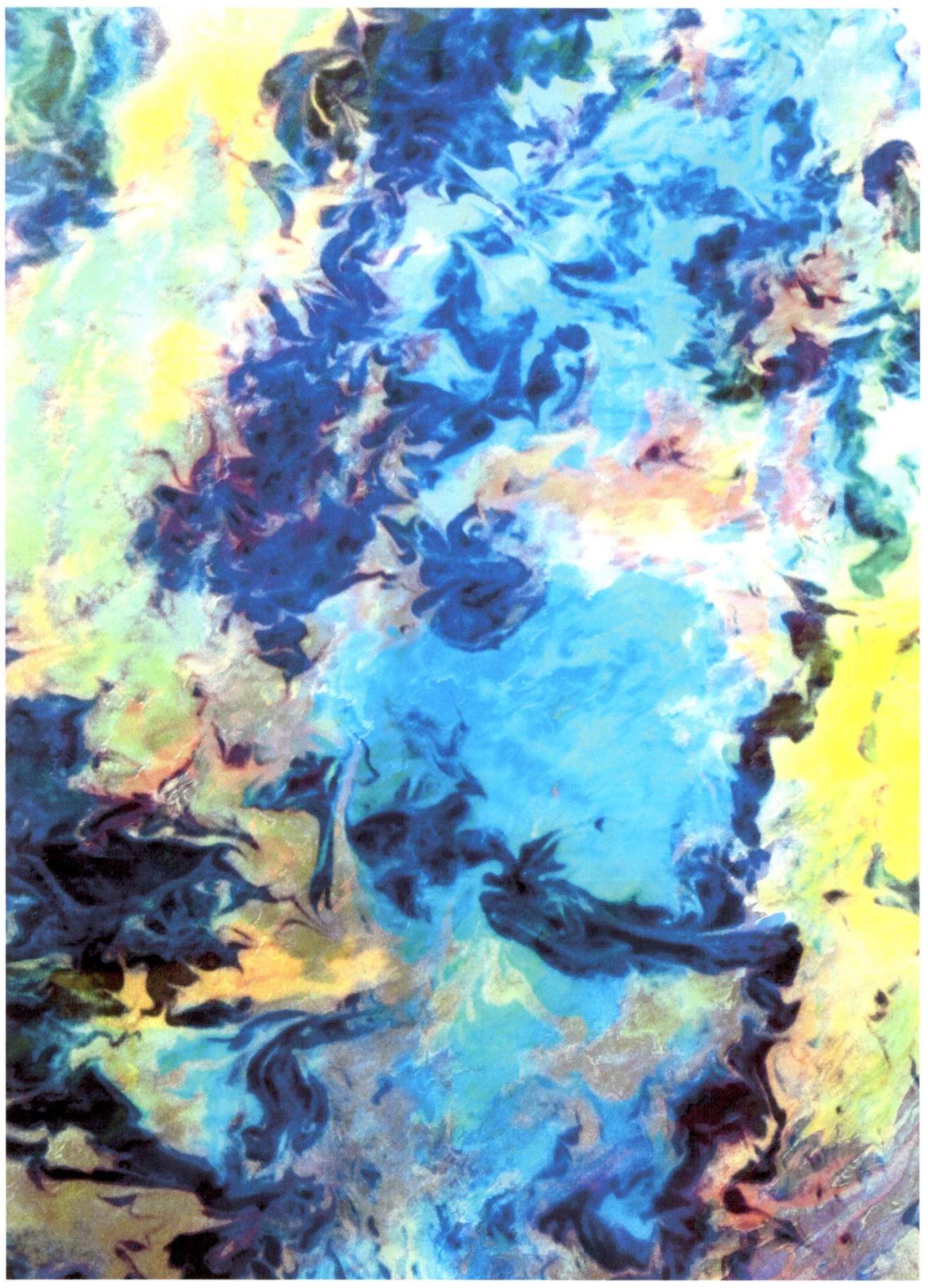

**DIPTYCHS, TRIPTYCHS
& TETRAPTYCHS**

THE DANTE PAINTINGS

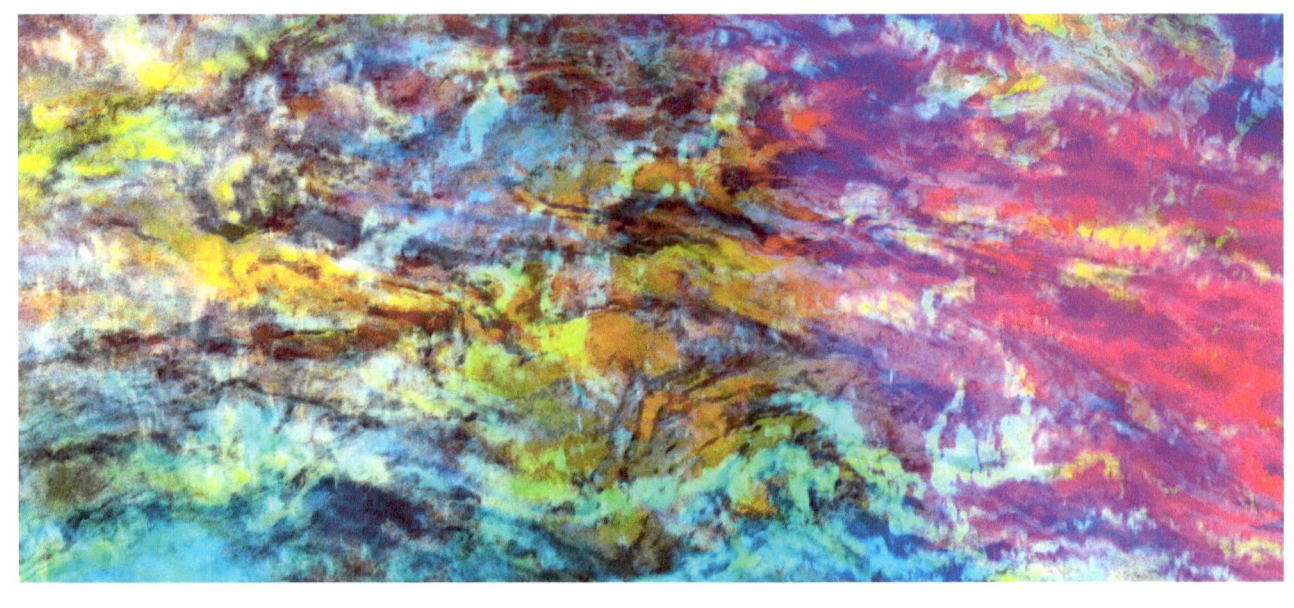
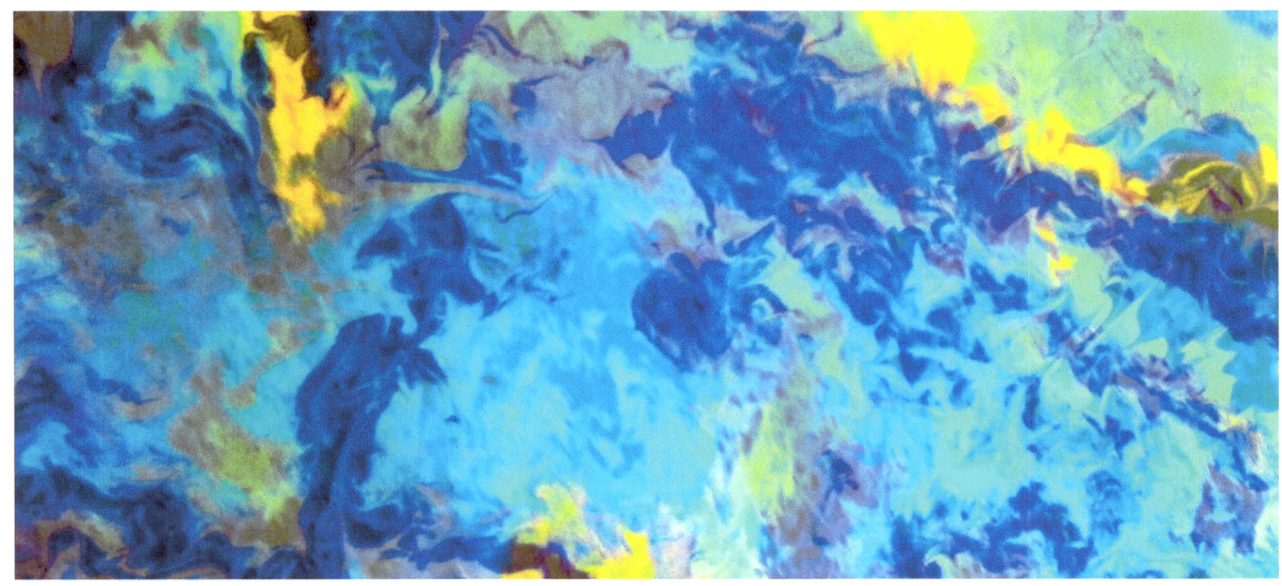
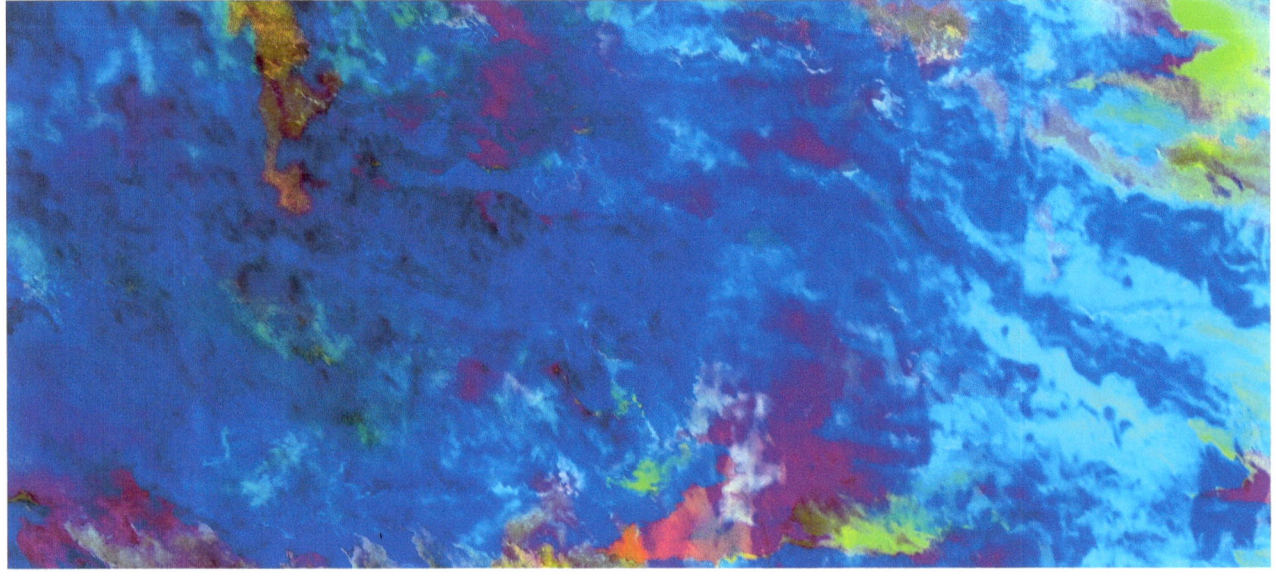

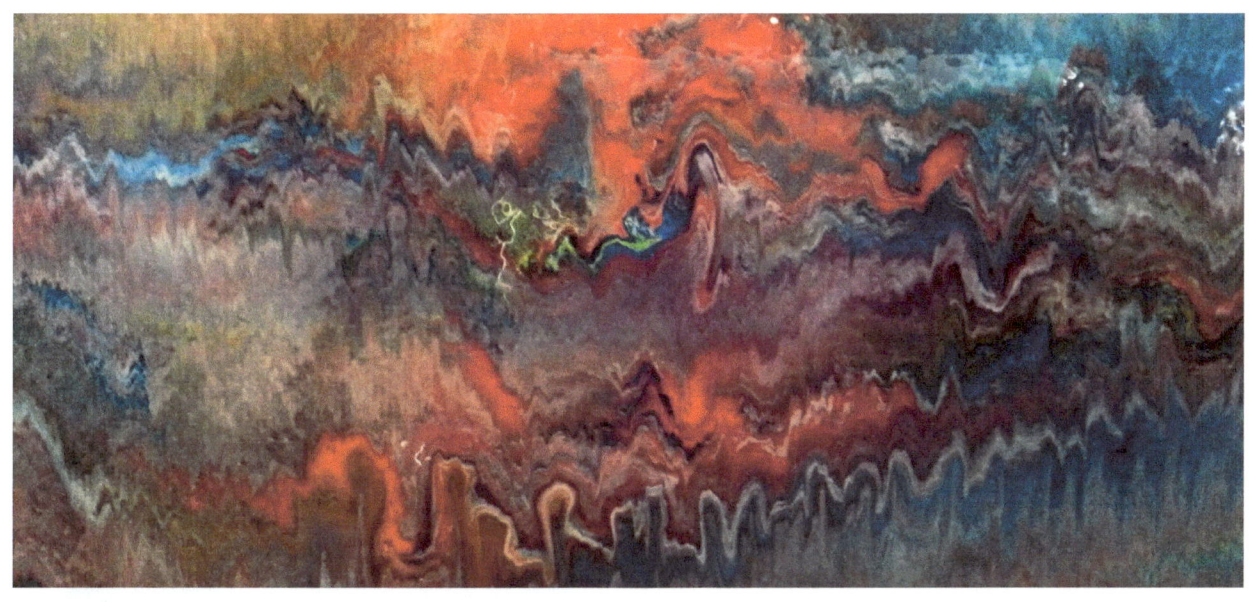
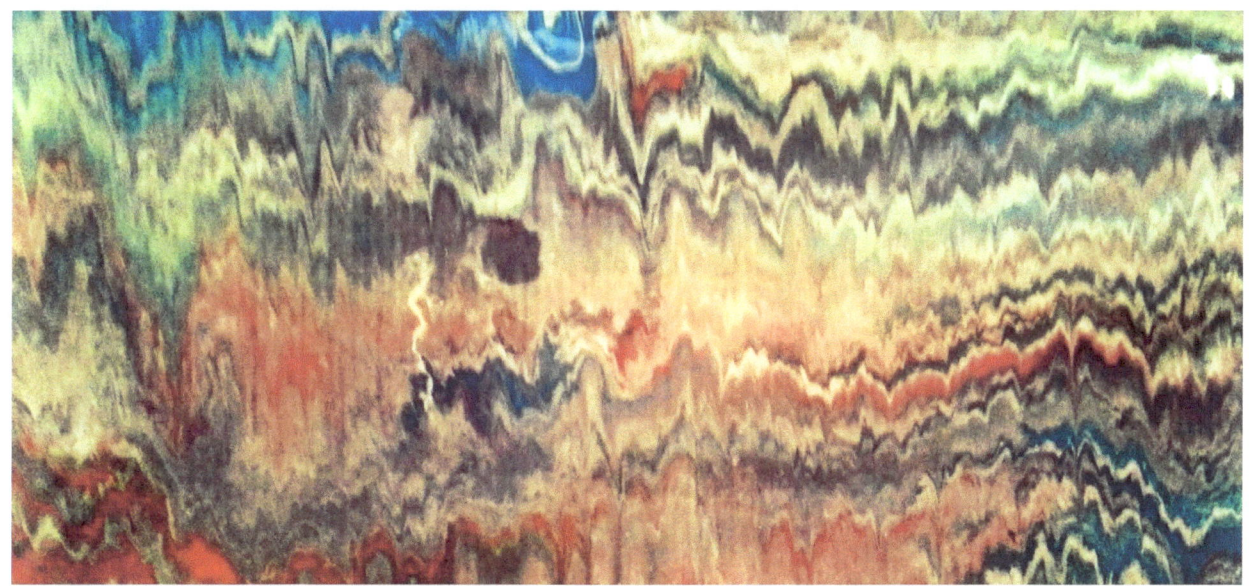
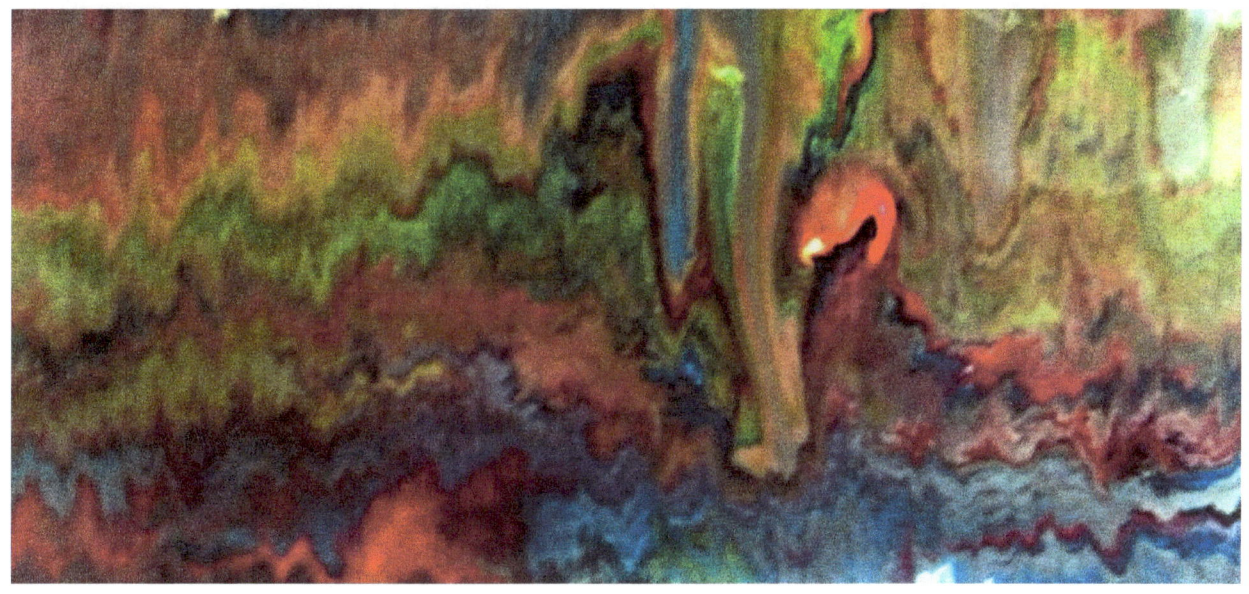

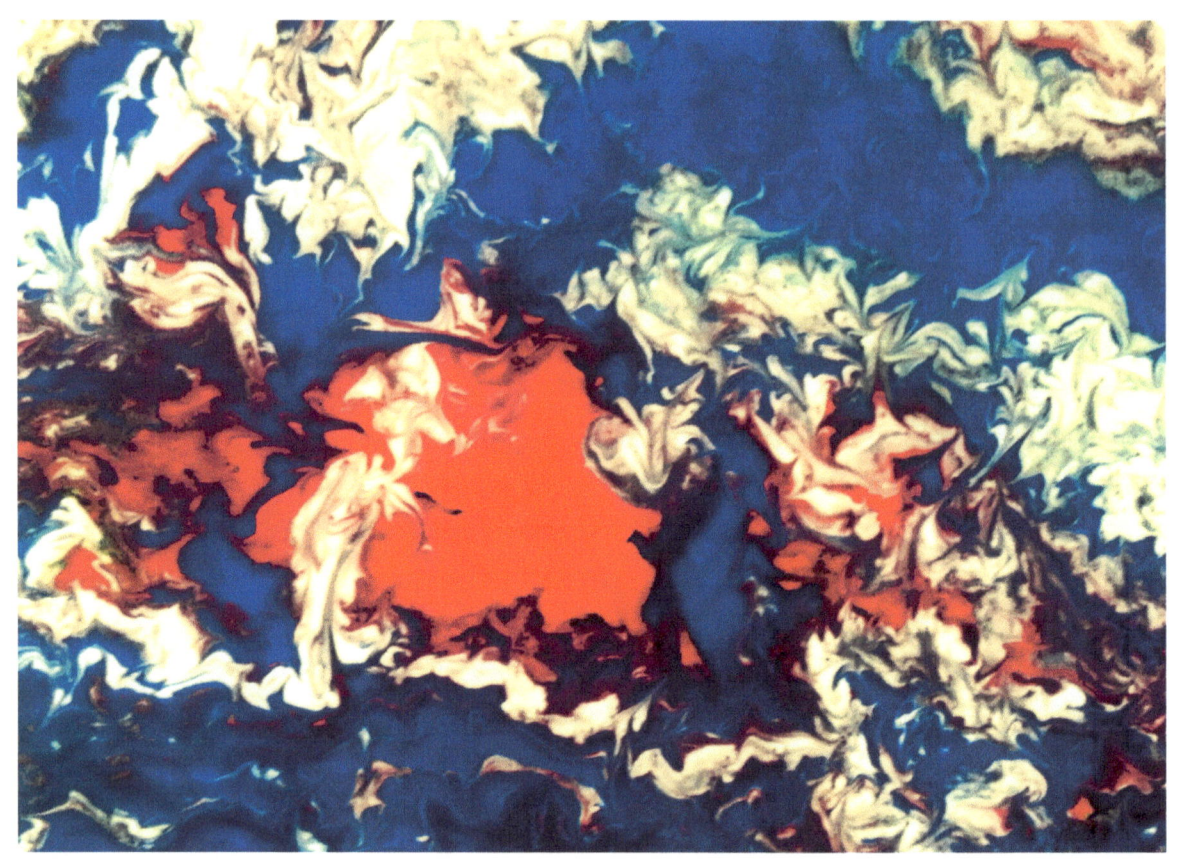
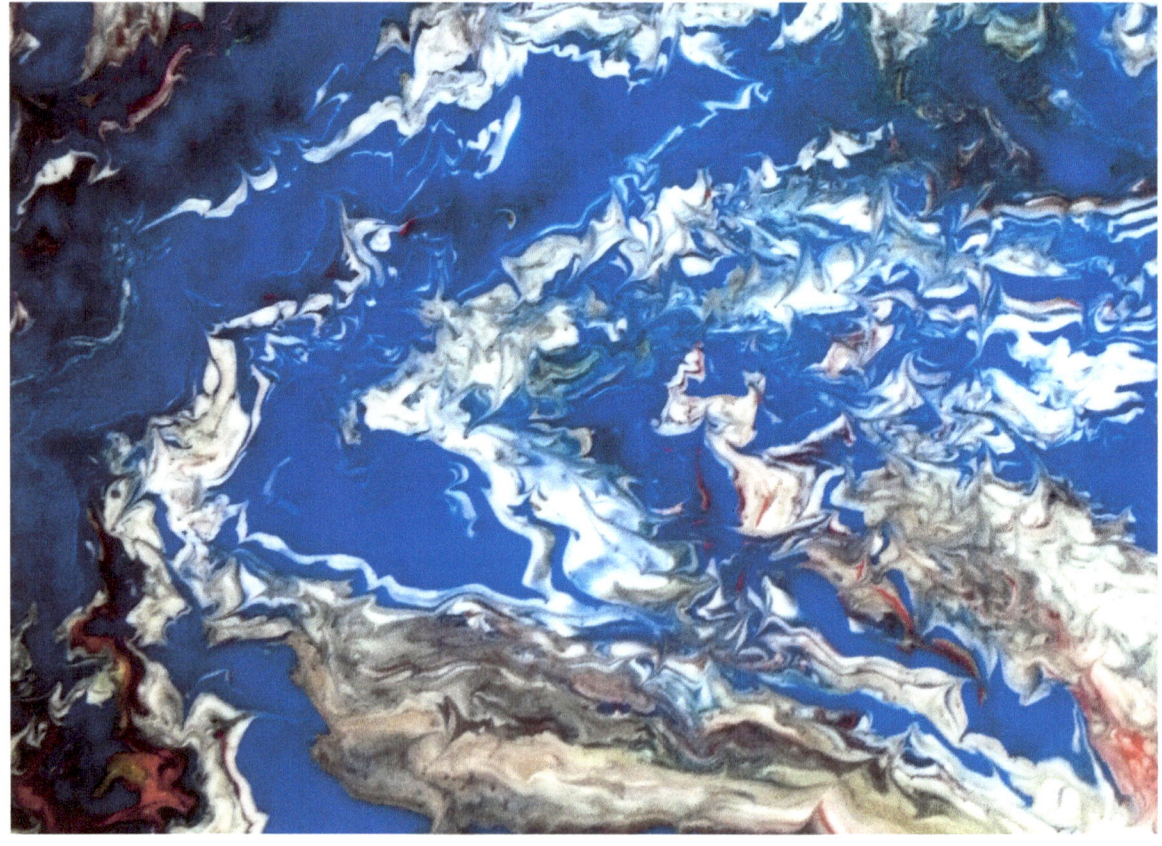

THE END!

© MAIA NEWLEY ART

www.ingramcontent.com/pod-product-compliance
Lightning Source LLC
Chambersburg PA
CBHW050357180526
45159CB00005B/2053